AUDREY FLACK

THE DAILY MUSE

Illustrations and Preface by Audrey Flack

Harry N. Abrams, Inc., Publishers, New York

Editor: Margaret Blythe Rennolds

ISBN 0–8109–1180–9

Preface

The phrases in this book have been gathered over the years. As I jotted them down, I found that each one held a special meaning for me. *The Daily Muse* is a way of sharing them.

While many of the thoughts deal with the inspiration of art and the artistic process, they can be applied to all aspects of life and work. They range from the provocative to the humorous; some are introspective

and some encourage action. Many are affirmations and can offer ways to deal with the stresses of everyday life. Others are philosophical and can cast a new light or put things in perspective.

The book contains fifty-three phrases. I designed decorative borders as a setting for them and colored them according to the seasons. I hope as you read and absorb the musings each week that they will act as an

inspiration. Opposite each one is a page with rules—a place for you to create and record your own thoughts. Labeled for each day of the week, these lined pages can also be used as a journal or calendar.

 I send you my very best wishes for a productive and inspired yearlong journey.

 A.F.

Paintings can be measured by energy levels.
Masterpieces generate the highest energy.

s

m

t

w

th

f

s

I think the
integrity in a work of art
is what makes its presence felt.
Either it's there or it isn't.

s

m

t

w

th

f

s

Artists generate the myth.
Because they work non-materially,
they can have clearer vision.

s

m

t

w

th

f

s

It is necessary to have areas of entry and exit in a work.
American Indians understood this
and left room for the "spirit breath" to get in and out.

s

m

t

w

th

f

s

"You must either be a work of art
or wear a work of art."

—Oscar Wilde

s

m

t

w

th

f

s

Art makes life more livable.
Art makes the self visible.

s

m

t

w

th

f

s

Visualize what you want to do before you do it.
Visualization is so powerful that
when you know what you want, you will get it.

s

m

t

w

th

f

s

When society becomes corrupt,
it is the role of the artist not just to reflect and record
but to purify.

s

m

t

w

th

f

s

Do artists need more time alone than others?
Is that why they have selected
a field where they work by themselves in a studio?

s

m

t

w

th

f

s

Artists use their skill
to bring a painting to a point where it begins to breathe.
Then it paints itself.

s

m

t

w

th

f

s

"Art should be more like a calling than a killing."

—John Perreault

s

m

t

w

th

f

s

Time is needed for regeneration.
Spring follows winter.
Creativity follows dry spells and fallow periods.

s

m

t

w

th

f

s

Our lifetime journey
is travel toward higher consciousness.
The creative process
is the vehicle artists use to travel.

s

m

t

w

th

f

s

You can't overcome fear
unless you are in a state of full attention.
When I concentrate on my work, I create an arena
in which I can move beyond my fears.

s _____

m _____

t _____

w _____

th _____

f _____

s _____

Watch out for fashion and trends in art—
they come and go like rising hemlines.

s

m

t

w

th

f

s

Success will never come
when you want it to or in the way you want it.
When you relax and release yourself from the struggle,
it finds you.

s

m

t

w

th

f

s

In my *vanitas* paintings
I often include a skull, a burning candle, and an hourglass—
all symbols of the passing of time.
This contemplation of death during life
heightens our awareness and helps us live more fully.

s _____

m _____

t _____

w _____

th _____

f _____

s _____

In the fifties I signed my name "A. Flack"
in order not to be exposed as a woman artist.

s

m

t

w

th

f

s

Be still and listen
to the voice within you that knows the truth:
paint from there.
Inspire others with your highest ideals.

s

m

t

w

th

f

s

Today I have decided to be happy,
to take responsibility for my own life
and state of mind.

s

m

t

w

th

f

s

Creating is an act of love:
you can't have someone else make love for you.

s

m

t

w

th

f

s

You can't do anything about the length of your life,
but you can do something about its depth and width.

s

m

t

w

th

f

s

Artists are the shamans of society,
they are the reflectors
and the visualizers of the spirit.

s

m

t

w

th

f

s

My work method has become holistic.
It has become a part of my whole life
and not just my whole life.

s

m

t

w

th

f

s

The ego is always thirsty and hungry—
it is never satisfied.
It should be left outside the studio door.

s

m

t

w

th

f

s

Drawings make a statement,
complete themselves,
and clear the way for new work.

s

m

t

w

th

f

s

"There are pictures that manifest education
and there are pictures that manifest love."

—Robert Henri, *The Art Spirit*

s

m

t

w

th

f

s

The desire for power and excess
disturbs and often prevents
reaching the desired goal of self-fulfillment.

s

m

t

w

th

f

s

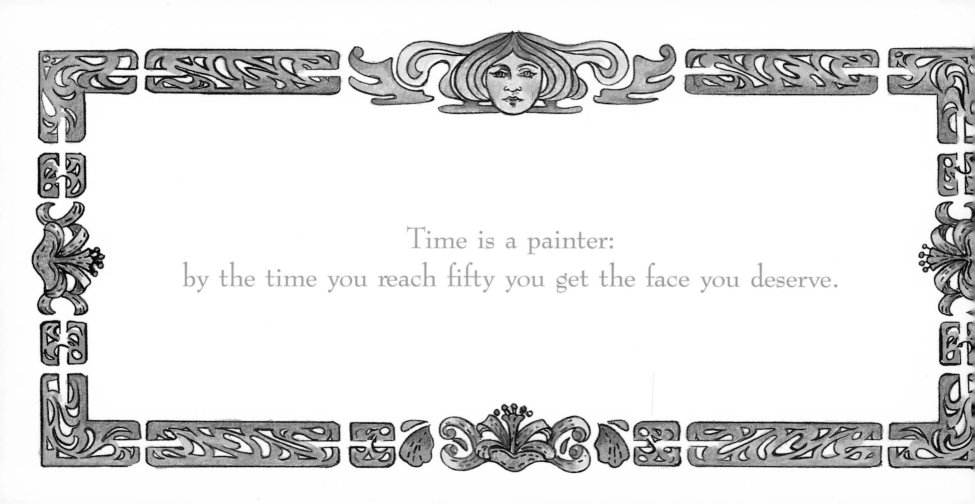

Time is a painter:
by the time you reach fifty you get the face you deserve.

s

m

t

w

th

f

s

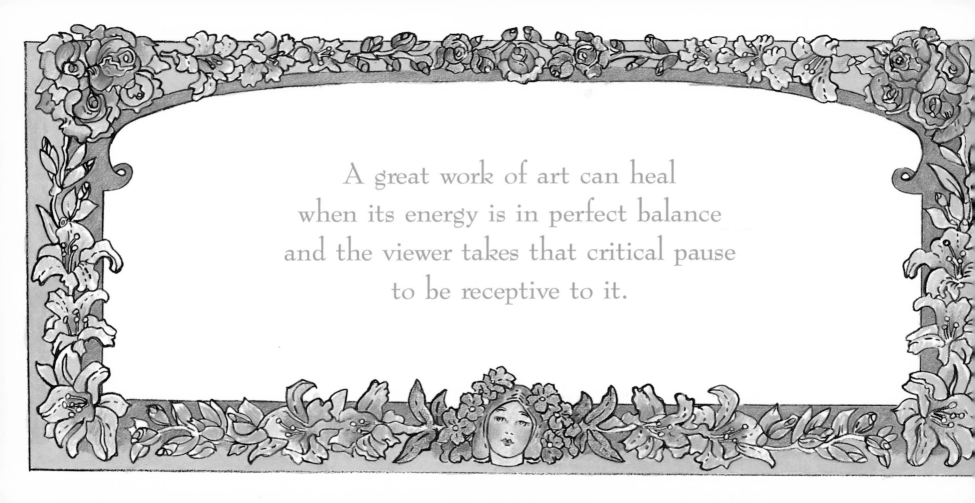

A great work of art can heal
when its energy is in perfect balance
and the viewer takes that critical pause
to be receptive to it.

s

m

t

w

th

f

s

If you can control your line, you can control your life.

s

m

t

w

th

f

s

When I was younger I cared about my masters—
De Kooning, Pollock, Kline.
Now my students want me to care about them.

—conversation with Grace Hartigan

s

m

t

w

th

f

s

Technique is not the result of itself,
it develops out of concept.

s

m

t

w

th

f

s

Delve more deeply with care and sensitivity
rather than spreading yourself too thin.
Clear any dark corners hanging over your life.

s

m

t

w

th

f

s

Life sends lessons over and over again,
until we see them as opportunities
and learn what we have to.

s

m

t

w

th

f

s

Painting a watercolor is like cleansing the mind.

s

m

t

w

th

f

s

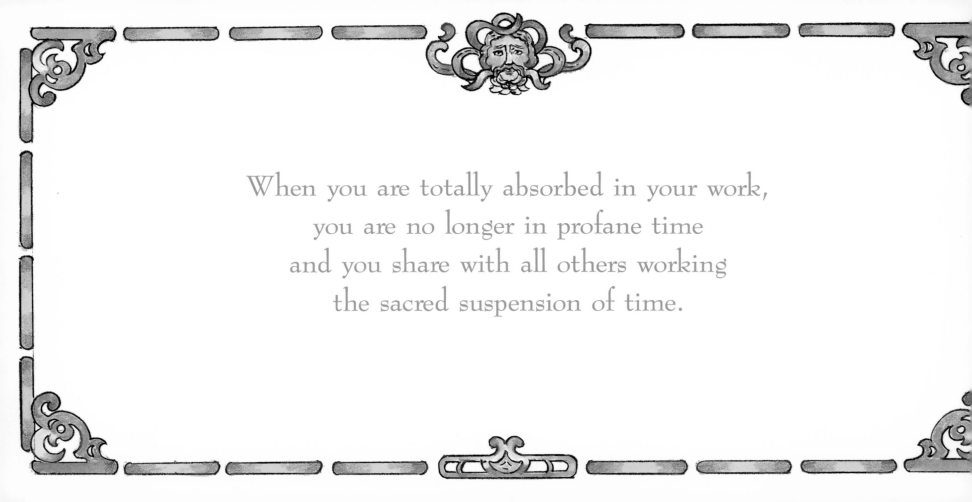

When you are totally absorbed in your work,
you are no longer in profane time
and you share with all others working
the sacred suspension of time.

s

m

t

w

th

f

s

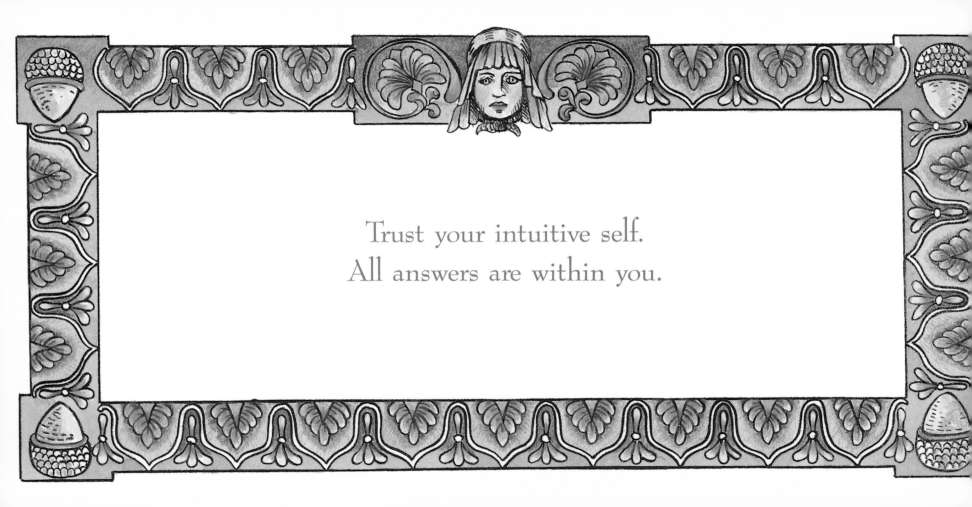

Trust your intuitive self.
All answers are within you.

s

m

t

w

th

f

s

It's one thing to be popular with the public
and another to become a tool of cultural resonance
and resurrect the collaborative myth.

s

m

t

w

th

f

s

Make beautiful, perfect work
at a time when the imperfect and ugly prevail.

s

m

t

w

th

f

s

"Beauty is an intangible thing:
it cannot be fixed on the surface
and the wear and tear of old age on the body
cannot defeat it."

—Robert Henri, *The Art Spirit*

s

m

t

w

th

f

s

At the right time, and only then, can you walk
into the fire, stand in the center of the flames, and stay there
for the amount of time needed to learn the lesson.
You can then leave without being singed or burnt.
Once attained, vision becomes startlingly clear.

s

m

t

w

th

f

s

Are there any new rocks?

s

m

t

w

th

f

s

Everything that is meant to happen
will happen when it is supposed to,
and not a moment before.

s

m

t

w

th

f

s

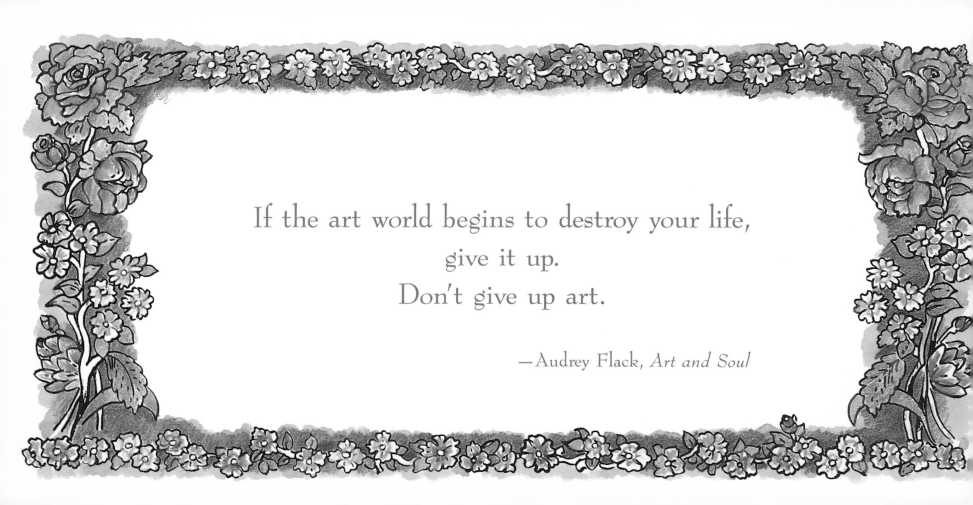

If the art world begins to destroy your life,
give it up.
Don't give up art.

—Audrey Flack, *Art and Soul*

s

m

t

w

th

f

s

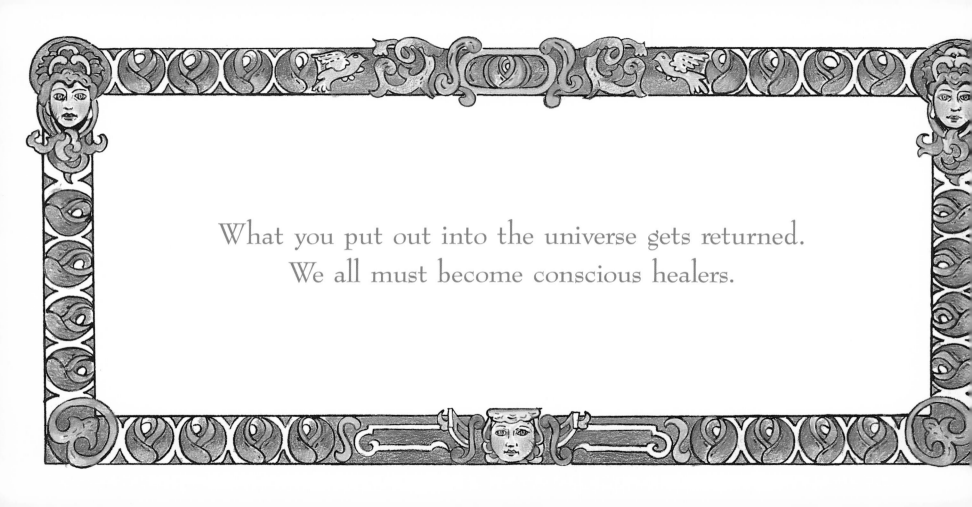

What you put out into the universe gets returned.
We all must become conscious healers.

s

m

t

w

th

f

s

Everything the eyes have seen is reflected in them.
I try to paint that.

s

m

t

w

th

f

s

Choose what conversation goes on in your head.
Our thoughts are our prayers and we are always praying.

s

m

t

w

th

f

s

A painting is the stored energy of the artist,
only to be released by the observer.

s

m

t

w

th

f

s

A painting is the visual shape and state of the artist's mind.

s

m

t

w

th

f

s

"There is a way back from fantasy
to reality and that way is Art."

—Sigmund Freud

s

m

t

w

th

f

s

"Walk your talk."

—American Indian saying

s

m

t

w

th

f

s

"With beauty may I walk
with beauty behind me may I walk
with beauty above me may I walk
with beauty below me may I walk
with beauty all around me may I walk

in old age wandering on
a trail of beauty may I walk
it is finished in beauty
it is finished in beauty."

—Navajo Indian Nightway Chant

s

m

t

w

th

f

s